ACTIVE
PRAYER
SERIES

Praying in color ™

Sybil MacBeth Drawing a New Path to God

PARACLETE PRESS
BREWSTER, MASSACHUSETTS

Praying in Color: Drawing a New Path to God

2009 Fifth Printing
2008 Fourth Printing
2007 First, Second, Third Printings

ISBN: 978-1-55725-512-9

Scripture quotations designated BCP are taken from the Book of Common Prayer 1979, Episcopal Church USA.
Scripture quotations designated KJV are taken from the King James Version (Authorized).
Scripture quotations designated LV are taken from the Latin Vulgate.
Scripture quotations designated NEB are taken from the New English Bible, copyright © 1970, Oxford University Press, Cambridge University Press.
Scripture quotations designated NIV are taken from the Holy Bible, New International Version®. NIV®. © 1973, 1978, 1984 by International Bible Society. Used by permission of Zondervan Publishing House. All rights reserved.
Scripture quotations designated NJB are taken from the New Jerusalem Bible, published and copyright © 1985 by Darton, Longman & Todd Ltd. and Doubleday, a division of Random House Inc., and used by permission of the publishers.
Scripture quotations designated NKJV are taken from the New King James Version. Copyright 1979, 1980, 1982, Thomas Nelson, Inc., Publishers. Used by permission.
Scripture quotations designated NRSV are taken from the New Revised Standard Version Bible, copyright © 1989 by the Division of Christian Education of the National Council of the Churches of Christ in the United States of America, and are used by permission. All rights reserved.
Scripture quotations designated RSV are taken from the Holy Bible, Revised Standard Version, copyright © 1946, 1952, 1971 by the Division of Christian Education of the National Council of the Churches of Christ in the United States of America, and are used by permission. All rights reserved.

Library of Congress Cataloging-in-Publication Data
MacBeth, Sybil.
 Praying in color : drawing a new path to God / Sybil MacBeth.
 p. cm.
 Includes bibliographical references.
 ISBN 978-1-55725-512-9
 1. Prayer--Christianity. 2. Color drawing. 3. Art and
religion. I. Title.
 BV227.M32 2007
 248.3'2--dc22

 2006035195

10 9 8 7 6 5

Published by Paraclete Press | Brewster, Massachusetts | www.paracletepress.com
Printed in China

For Cindy Overmyer

who first handed me colored markers
and gave me permission to make imperfect drawings

contents

Part 1 From Pen and Paper to Prayer

Part 2 Getting Started

Part 3 The Practice

Part 4 Using Color to Pray...

Part 1 From Pen and Paper to Prayer

Chapter -5

Prayer Dilemmas

Here are some reasons that you might want to read this book. If any of these dilemmas describe your efforts at prayer, then you and I stand on some common, shaky ground.

- You make a list of the people for whom you want to pray and then don't know what to pray for.

- You can't sit still long enough to get past the "Our Father" or "Hello God" step.

- Your prayers feel more like a list for Santa Claus than a love letter to God.

- You fumble for the right words and deem the effort hopeless.

- You dump the contents of your heart and mind on God and then wish you hadn't.

You turn to a prayer book or the Bible for solace and guidance, and then fail to find the verse that describes your immediate need.

Your prayers feel too puny, too self-centered, too phony . . . or just somehow . . . inadequate.

You're bored with the same old prayers that you've said since kindergarten.

You ask that God's will be done then cross your fingers and hope you can bear the results.

You promise to pray for others, and then forget who they are.

You can't wait for your prayer time to be over and done with.

You start to pray and realize that you're thinking about paying the bills.

Praying for others feels like checking off errands on a "to-do" list.

Your spirit and body reach a place of calm and stillness in prayer and then you fall asleep.

You want to like the act of praying, but it is more often obligation and drudgery than joy.

You're sure that everyone you know is a better and more effective pray-er than you are.

Praying in Color

Chapter -4

Praying in Color

Praying in Color is an active, meditative, playful prayer practice. It is both process and product. The process involves a re-entry into the childlike world of coloring and improvising. The product is a colorful design or drawing that is a visual reminder of the time spent in prayer.

Now, before you slam this book shut with the panicky feeling that this is an exercise for artists, please wait. This practice requires no skill. I cannot draw a cat. Or a dog. Or anything else for that matter. Throughout my years in school, C's in Art were the blemish on an otherwise rosy-faced and squeaky-clean report card. My artist mother and grandmother could only sigh and wonder what had gone awry in the tossing of the genetic salad.

But in spite of artistic deficiencies, I have always loved color. The stadium-seating of the 48 crayons in the Crayola box, the sweet smell of paper and wax, and the feel of the thin cylinders rolling around in my hand were

an early experience of worship. A little altar was set before me with all those colors waiting to evangelize the world. So much potential for beauty and transformation—it seemed a terrible injustice that what I drew was so ugly.

The irony and miracle for me is that now, in my adulthood, God has taken one of my passions—color; combined it with one of my inadequacies—drawing; added it to my antsy and improvisational personality; and given me a new way to pray. "My grace is sufficient for you, for my power is made perfect in weakness" (2 Cor. 12:9 NIV). I think I have an inkling of what Paul felt when the Lord spoke those words to him.

So I repeat: no skill is required. If you are a visual or kinesthetic learner, a distractible or impatient soul, a word-weary pray-er or just a person looking for a new way to pray, I hope you will find this practice helpful. If not, I hope it will simply jump start some new prayer ideas that work for you.

Chapter -3

Prayer Frustration

I am a mathematics instructor by vocation, a dancer and doodler by avocation, and a pray-er by birth. My mother breathed prayers into me from the moment I was born. While God "knit me together in my mother's womb" (Ps. 139:13 NRSV), my mother said "Amen"—let it be so—with every stitch. As a result, I have no memory of a God-free life. My earliest childhood memories are of my mother sitting on the edge of my bed, stroking my hair, and reciting the Mary Baker Eddy prayer for children:

> Father-Mother God,
> Loving me,—
> Guard me when I sleep;
> Guide my little feet
> Up to Thee.

I liked the prayer. It was simple to say and easy to visualize. The fact that I saw myself upside down with my toes wiggling towards God was not a

7

problem. As a footling breech at birth, it seemed the natural way to approach God. The prayer was also less scary than the one that both my little Catholic and other Protestant friends said—"and if I die before I wake, I pray the Lord my soul to take." Feet I could understand, but death and souls were the stuff of the ghost stories my big brother told.

With prayer so deeply ingrained into my being, I should be an expert. But, if Prayer is a credit course in the kingdom of heaven, I'm in trouble. The report card grade of C- would probably say: "not enough detail, wandering attention, too many clichés, too little time and effort, too self-focused, too much fidgeting, too much whining. . . ."

I've never been much of a prayer warrior; I cannot fire out eloquent, television-worthy prayers. Instead, I'm more like a prayer popper. I pray a lot, but in fits and spurts, half-formed pleas and intercessions, and bursts of gratitude and rage.

Although I am no longer a member of the church that soaked my childhood in prayer, I cling to one of the principles that I learned there: that prayer is an every-moment activity—not just on Sundays or at the dinner table or at bedtime. Prayer is the glue that holds all of the pieces of life together in a spiritual whole. It reminds us of who we are and whose we are. My early Sunday school teachers and my mother took seriously the directive from 1 Thessalonians 5:17: "Pray without ceasing" (KJV). Other translations and versions of the Bible use similar words: "pray constantly" (RSV), "pray continually" (NEB), "*sine intermissione orate*" (LV)—which might be translated *without intermission speak*. In any language, the challenge is clear.

Although those words could feel like an order for an impossible mission, they seem to me more like a personal invitation. *Be with God here and now; the party has begun.* But as with all party invitations, my anxiety rises. "What shall I wear?" The clothing in this case is the kind of prayer I will pray. That's

why prayer forms fascinate me. I know about centering prayer, contemplative prayer, walking prayer, healing prayer, soaking prayer, meditation, praying in tongues—I took the workshops and read the books. I've dabbled in all of them. But a short attention span and a proclivity for daydreams hamper my efforts. Five or six sentences or breaths into a well-intentioned prayer, I lose focus. The ungraded math papers on the desk noodle their way into my thoughts. Anxiety about my inadequate parenting joins in the conversation. The words of my prayers and the words of my distractions collide in an unholy mess. On a good day, when words flow with more ease, I become so impressed with my successful articulation that I become the center of my own worship. It is not a reverent sight.

With feelings of guilt and inadequacy, I've thought about bagging the whole prayer exercise. But I have a priest friend named, appropriately enough, *Merry*, who encourages me: "If it's worth doing, it's worth doing poorly," she says. Besides, there's that deep, unrelenting hunger to know God. Prayer, even below-average prayer, is my feeble effort to get acquainted.

Chapter ·2

Prayer Popping

As a prayer popper, I stay in touch with God. I send lots of spiritual postcards. Little bits and bytes of adoration, supplication, and information attached to prayer darts speed in God's direction all day long. A friend of mine calls postcards "maintenance mail." Instead of waiting to write a Pulitzer-prize winning letter, she sends frequent postcards to maintain the relationship. It is a good means of communication, certainly better than nothing. But thinking that any relationship will grow when I'm only willing to commit two or three minutes of time or 2 inches by 3 inches of space is delusion. How often can I receive postcards from a friend that say "All's well, hope you're okay, thinking of you, back soon," and believe that I am really important? Though God probably appreciates my regular check-ins, "Hi God, Bye God" doesn't feel much like a formula for creating intimacy or a relationship with much depth.

For me, intimacy requires more than a minute here and there; it requires time. And it requires time after time of time. The word "intimacy" has its roots in an alteration of the Latin *intime* (Merriam-Webster-online). Although

there are no etymological connections, adding a space results in the sweet coincidence of *in time*.

Since words elude me when I need them most, I learned long ago that I cannot count on *quality* time with God when I want to pray. I need *quantity* and regularity. Quality is not something I can predict. My husband, Andy, and I might schedule an elaborate evening out with candles and a gourmet meal, but there is no guarantee that we'll have a wonderful time. Much of our intimacy has been created in the daily-daily of spending time together—chopping onions and peppers side-by-side in the kitchen, reading together on the couch, sitting on the front step watching our sons ride bikes, and making plans for our life together.

So I need a way to pray that gives me time. I need a way to pray that does not require lengthy, prize-winning words. I need a way to pray that suits my short attention span, my restless body, and my inclination to live in my head.

Chapter -1

Praying for Others

I feel quite free to make a mess of my personal prayer life; but when someone says, "Please pray for me," they are not just saying "Let's have lunch sometime." They are issuing an invitation into the depths of their lives and their humanity—and often with some urgency. They are publicly exposing their vulnerability, sorrow, and fear. Something about their life is so out-of-control that they call upon the likes of me for help. I warn them: sometimes the people I've prayed for have died. It's a risk.

There's also the risk that instead of praying for them, I'll just worry about them. And worry is not a substitute for prayer. Worry is a *starting place*, but not a *staying place*.

As a *starting place*, worry is a psychophysical signal that something is wrong. Like guilt, it lets me know that something is askew or not quite right in the universe. I'm not a proponent of guilt-busting or even worry-busting. If I chase guilt and worry away too quickly, I miss the message they bring. They arrive uninvited, but I may need them to stick around for a while. They are my wake-up call, my psychic and spiritual reveille. Both guilt and

worry can trumpet, "Get off your duff, get out and do something, get your act together, get your hands off, get out of this situation. . . ." But almost always they say, "Get on your knees; this is more than you can handle alone." Worry invites me into prayer.

As a *staying place*, worry can be self-indulgent, paralyzing, draining, and controlling. It conjures up the dark side of my imaginative gifts and consumes my energy. It is no less evil or titillating than pornography. When I take worry into prayer, it doesn't disappear, but it becomes smaller. I see it for its true self—an imposter that masks itself as action and lassoes me into inaction. Brought into prayer, it sits next to me and whimpers for its former place of honor and power. When I focus on my prayer, on that conscious effort to engage the presence of God, worry heels, stays, and sometimes even rolls over and dies.

So when people ask for my prayers, I take a deep breath, put the choke chain on worry, and walk, leash in hand, into that place called prayer. When I ask people to pray for me, I hope they will do the same. I don't want them to worry about the details of my request. Obsessing about my sorrow, "tsking" about my wayward children, peeping through the keyhole of my confessions, fantasizing my diagnosis and prognosis, or writing my obituary is not their task. Their task is to fill the universe with good thoughts, to wrap me in God's love, to give me hope, and to intercede for my healing. I want them to reconnect my hands and heart with God's when I'm too fraught with fear or sadness to do it by myself. When I pray for others, I assume they are asking for the same respect. I assume they want me to hold my obsessive and voyeuristic thoughts at a distance as well.

It's a daunting responsibility to say "I will" to a prayer request; and it is with some caution and trepidation that I make the offer, "Would you like me to pray for you?"

13

Chapter 0

Praying in a New Way

About three years ago and over a two-semester period starting in September, I had a multitude of family, friends, and colleagues stricken with a litany of terrible cancers—lung, brain, breast. The amount of disease and suffering within my circle of friends was overwhelming.

Did I pray? I tried. I shot a daily quiver-full of pathetic little prayers to God for healing, remission, comfort, courage, long life, miracles, God's will, and a host of other outcomes—all the while knowing that my prayers were not the deal breaker or a magic bullet for a cure. But I also knew that my worry and outrage created an aura of fear and negativity that threatened to overpower my faith. My friends deserved better support than just "praying scared."

By May, at the end of the school year, I had half-a-dozen friends and family members—Sue, Chuck, Peter . . . —on my critical prayer list. With three months of sabbatical from my work as a math professor, I retreated to the back porch of my house, determined to catch up on nine months of a

14

somewhat neglected spiritual life. With no papers to grade and no lessons to prepare, I was also free to indulge in my number one form of meditation, relaxation, and procrastination: doodling. One morning, I lugged a basket of colored pencils and markers to the center of the porch's glass-top table.

Now remember, I have never been able to draw a cat, a dog, or anything else for that matter. But I love color and shape and movement. Improvisational drawing, a/k/a doodling, allows me to combine those loves on paper. So I opened a pad of Manila paper and started to draw. I doodled a random shape into existence with a thin black pen. Without even realizing it, I wrote a name in the center of the shape. The name belonged to one of the people on my prayer list. I stayed with the same shape and the name, adding detail and color to the drawing. Each dot, each line, and each stroke of color became another moment of time spent with the person in the center. The focus of the drawing was the person whose name stared at me from the paper.

When the time seemed right, I moved to a different place on the page and drew another shape with another name in the middle. I embellished the new shape with detail, lines, and color. I drew new shapes and names until friends and family formed a colorful community of designs on the page.

To my surprise, I had not just doodled, I had prayed.

The entire prayer time was silent and wordless. I felt no need to supply a pious or pleading monologue. The feeling of despair and discouragement and my usual urgency to flee from the sickness and distress of others were absent. I had thought "of" each person as I drew, but not "about" each person. The details of their prayer needs were spared, and I could just *sit* with them in a variation on stillness.

When the drawing was finished, there was a visual record of my prayers. The images stayed in my mind and I carried them—and sometimes the

actual page—with me wherever I went. Now I had a visual prayer list that I was less likely to lose in the detritus of my car or purse. The yellow and green "Sue" prayer popped into my mind at other times during the day, and I prayed for her on the spot. I'd see Peter in purple and gray and know that God was swaddling him in a "coat of many colors." I saw the whole array of my loved ones on the page and knew that, in spite of my fear and faltering words, I could hold them in prayer.

Part 2 Getting Started

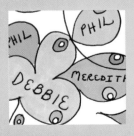

Chapter 1

Supplies

You will need paper and colored markers or pencils. I also use a thin black, roller-point pen to make the initial outlines and add detail. I usually draw in a hardback marble composition book in which I keep my daily journal. If you are distracted by the lines or want to be able to fold up your drawing and drop it in your pocket, purse, or briefcase, buy a drawing pad from an art supply store or a discount department store. I close my eyes when I pass the fancy leather-bound or handmade journals of paper. They can be so beautiful that my intimidation level prevents me from writing or drawing in them at all. Computer paper, newsprint, or even the back of an envelope will work in a pinch.

Markers and colored pencils are available at the same stores as paper. I avoid washable markers because they tend to smear. If you want to purchase nice markers or pencils, invest in brands at an art supply store. Many of the

people who work in these stores are artists who have experience with the supplies. They will advocate for their favorite brands of markers or pencils and tell you the pros and cons of each kind. These items can also be purchased online. The markers I use are permanent and come in almost two hundred colors. The pencils contain soft lead and come in so many lush, beautiful colors that they forgive any inadequacy in my drawing. Both markers and pencils come in sets, but you can also buy them individually so that you can choose your own colors. Start with twelve—a discipleship of markers—or if you're more daring, thirteen—the Judas dozen.

You might ask, "Why do I have to spend money to pray? Or why can't I use crayons?" The answers are, of course, "You don't have to" and "You can." But I can only testify to my own experience: Having decent supplies (but not elegant or exotic ones) makes drawing more satisfying and aesthetically pleasing. If the cheap markers smear all over the paper, get all over my hands, and the result is really ugly, I'm likely to give up. Crayons can work, but I'm not enough of an artist to manipulate them well.

Those may seem like superficial and unspiritual reasons, but that's where I start. I'm distracted and unskilled and I need a bit of gratification to stay on task. Buy the supplies you need to maintain your interest and focus.

Chapter 2

Time and Place

This prayer form can take as little or as much time as you have or want to commit. A minimum amount might be fifteen minutes. I find a half-hour works well. Any time of the day will work. If I draw in the morning, I can carry the names during the day. If I pray in color at night, I carry a feeling of blessing with me to bed. I can use my prayer chart the next day as well.

A quiet room with a table is ideal. The reality, however, is that true quiet is hard to come by. I have prayed at a table on my back porch (my ideal spot), but also in the car (as a passenger), in an airplane, on the couch, in a coffee shop, or just about anywhere. A clipboard turns any place into a prayer corner. In Matthew 6, Jesus advises us: "But when you pray, go into your room [or closet] and shut the door . . ." (Mt. 6:6 RSV). The action of hunkering down over a pad of paper tends to create its own prayer room or space and allows me to shut out extraneous activity.

Setting up the space can also be part of the prayer ritual. Men and women prepare an altar for worship and Communion by arranging flowers, spreading the fair linen, placing the chalice and paten on the table, and lighting candles. Find a simple way to create a makeshift prayer place. Light a candle. Walk outside and clip a flower or something green to put in a small vase. I clear a space, bring out the markers, and lay out the paper. These basic actions announce to my mind and body my entrance into a place set apart for something special. If prayer is the way that humans rap on the door of the Creator, then colored markers are my brass knocker. The markers and paper set the stage for my prayer time.

Once you gather your supplies together, you might want to segue into prayer using one of the following ideas:

Recite or read a passage from Scripture. One that seems applicable to this practice is Romans 8:26: ". . . the Spirit helps us in our weakness; for we do not know how to pray as we ought, but that very Spirit intercedes with sighs too deep for words" (NRSV). Say it several times.

Sing a verse of a favorite hymn.

Say a prayer to gather the pieces of your body, mind, and spirit together.

Sit in your chair and breathe for a minute or two.

Do a few minutes of exercise. Stretch. Reach to the sky, touch your toes. Bend your knees. Wiggle your hips. Invite your body into prayer with you.

Take several deep breaths. Let out a noisy sigh after each one. With each exhale, release the "To Do" list.

And . . . if none of those ideas appeals, just pick up your pen, your markers, and begin to pray in color.

Remember, this is an all-day prayer event. Drawing is only half the prayer. The other half is transporting the visual memories—either in your mind or on paper—so you can pray throughout the day. The images are the visual alarm clock or Sanctus bells that remind us to pray.

Part 3 The Practice

Chapter 3

The Steps

Draw a shape on the page—a triangle, trapezoid, squiggly line, or imperfect circle. Write the name of a person for whom you want to pray in or near the shape.

Other ways to begin...

Write "God," "Jesus," or one of the infinite names for the Almighty in the first shape. This can serve as a reminder that God is ever-present in your prayer and your work.

Write your own name in the shape. Sometimes, the first people who need prayers of intercession are ourselves.

Leave the first shape empty with the idea that the mystery of God is in the midst of the prayer.

27

Add detail to the drawing. This might be dots, lines, circles, zigzags, or whatever your hand wants to do.

Don't analyze your next stroke too much. Dismiss the art critic from the room. This is not about creating a work of art; it's about creating visual images for the mind and the heart to remember.

Think of this as kinesthetic improvisation, a kind of praying in tongues for the fingers.

Continue to enhance the drawing. Think of each stroke and each moment as time that you spend with the person in prayer.

The written name and the emerging picture may evoke words and thoughts for the person. They add a new layer to your prayer experience.

Words, however, are unnecessary. Sometimes, we do not know what to say; the mere act of sitting with this person and keeping them as the focus of our intention can be as powerful as words.

I try not to insert words into the process. It seems to give my mind the "inch" that it needs to spin "miles" of extraneous thought.

Keep drawing until the image feels finished.

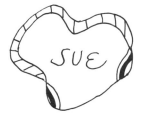

At some point, your mind will probably wander. In *Seeds of Contemplation*, Thomas Merton said, "If you have never had any distractions, you don't know how to pray."[1] Distractions are as much about being human as hair and heartaches. Make no judgments about your ability to pray based on their uninvited appearance.

Repeat the person's name to yourself as a way of corralling distracting thoughts. Think about the face or the entire person as if you were sitting with him or her in conversation.

Add color to the picture. Choose colors that will stay in your memory, that you particularly like, or that remind you of the person for whom you pray.

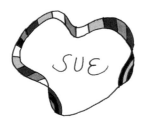

Try various pens, markers, or pencils. One person discovered *gel* pens. They come in an assortment of colors and are easy to use.

When the drawing and praying for the first person are completed, move to another space on the page. Draw a new shape or design to create a place for the name of a different person.

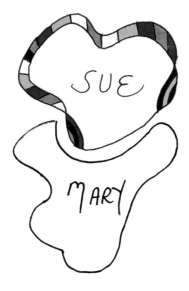

When you move your focus from one person to the next, you can, if it seems appropriate, offer a closing verbal prayer, an "Amen," or "I'll be back."

If the needs and concerns of the first person are particularly great, take several deep breaths to release any anxiety that you might carry to the next person. Or stand up for a moment and physically shake away those cares.

Sometimes I move directly from one person to another, knowing that we are connected in our pain and in our joy.

Repeat the process of drawing. Add detail and color the same way you did with the first person.

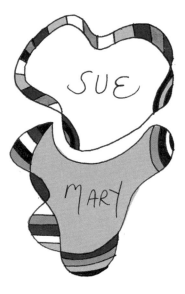

Praying for others is called *intercessory* prayer. When we offer intercessions, we are asking God for a change of direction in the present course of someone else's life. This might be the healing of their physical body, the reconciliation of relationships, or any other way in which their life is out of kilter. When we pray for others we become part of God's compassion modeled for us by Jesus.

Intercessions are also appropriate for countries, political issues, world crises, or even pets. Your entries might include any creatures or collections of humanity that are in your mind or on your heart.

31

Add a new person to the prayer "list."

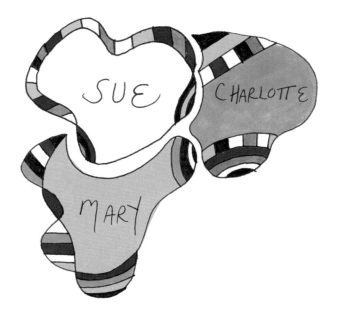

 In the process of this wordless prayer form, daydreams and distractions will probably enter your mind and demand center stage. Notice them, but don't dance with them. Refocus on the person for whom you pray.

 If a thought returns more than once, write a single word on the page to remind you to address it later. If it's an obsessive thought, think of it as bathed in the colors of your prayers and not able to control you. If it's a task or chore that's calling you, write a one-word reminder so you can release it for future attention, but not forget it.

Add another person to the drawing.

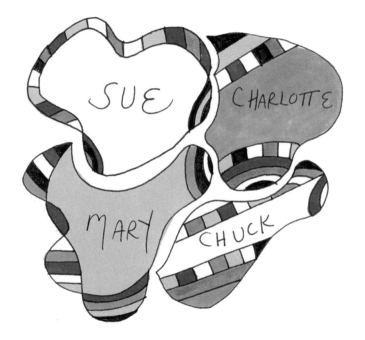

There is no order in which the drawing and coloring must be performed. Sometimes, I draw the entire prayer chart first, then return and color the images. This gives me a second chance to visit the people for whom I intercede.

Draw with pen and colors until you have created an image or icon for all of the people for whom you want to pray. Linger with the page in front of you. Let the names, images, and colors imprint themselves on your brain. Spend another moment with each person in silence or say a short verbal prayer or "Amen" if that seems appropriate. Take the journal or page with you, if you can. Place it on your desk, refrigerator, or someplace where your eyes will scan it during the day.

Sometimes I include two people in one space—my children, a couple, my son and daughter-in-law, families who are traveling together.

When you are finished, do something physical or verbal to release the burdens of the people on the page. Be intentional about the release. It may not be useful or healthy to hold the suffering of others in our body.

A flash of the image in your mind during the day is a reminder that you have committed these persons to the care of God. It is also a reminder that you have chosen not to worry but to pray for them.

Whenever worry about a person seeps into your consciousness, picture them in color surrounded by the love and care you offered when you sat with them in prayer. Envision them in the care and presence of God. Act as if you really believe that God will take care of them.

The next day, you may choose to draw a new prayer icon. Or instead of creating a new one, enhance the original in several ways. Add other names to your community of color. Some of these names might be the family and friends of people already on the page. Make new shapes for them if space permits, or write their names nearby. Another way to expand the original drawing is to write specific requests, biddings, or thoughts near a person's name. Words may come after you have spent some time of silence with each person.

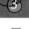
I use the word *icon* with the understanding that an icon is an image that helps us to see God. We do not worship the image; it has a transparency about it that lets us see through it to a deeper experience of God and God's presence.

As you pray throughout the day using the icon, words may come that help you to articulate and clarify your intercessions. If the words deteriorate into worried or quick-fix jabber, return to the visual, nonverbal images on the page.

Chapter 4

Prayer or Play?

Does this carnival of pens and colored markers really count as prayer? Or is it a sanctimonious ploy, a way to say that I've prayed when really I've just doodled, colored, and played? Does prayer have to be a totally intense and serious activity? Can a spiritual practice be both prayer and play?

During Lent a few years ago, I offered my first workshop entitled "Praying in Color." It was part of a parish's Wednesday evening adult series on prayer forms. Participants came to the class without much advance warning of what to expect. They selected some markers and were given paper, while I stood up front equipped with the quintessentially Episcopal educational tools—easel, newsprint, and permanent markers in many colors. Together we created a parish prayer drawing.

What I noticed in the hour we spent together was that most people were open to an unfamiliar way of praying. It was a new adventure. They seemed intent on drawing but not intense. Some people dutifully stuck with me through the entire instructed process, but others got the hang of it, found

their own rhythm, and drew their own prayer needs and intercessions. There was a sense of ease in the room. I suspect that the markers and paper were like the props we use in our everyday life to make us feel comfortable. Babies drag blankets or suck their thumbs. Children carry dolls, action figures, and stuffed animals. Teenagers, men, and women tote purses, briefcases, cell phones, iPods, and all sorts of technological paraphernalia. All of those things give us something to hold onto when we enter unfamiliar places and situations. Markers and paper may just be the set of toys that some of us need to enter that sometimes awkward and uncomfortable place of prayer.

We can listen and concentrate best when we are seemingly distracted by other activity—in other words, when we are allowed to play. The fact that our hands are busy does not mean we aren't paying attention. When I accused my then-five-year-old son of not listening while I read aloud *The Lion, the Witch, and the Wardrobe*, he proceeded to retell the story almost verbatim.

In *What the Body Wants*, Cynthia Winton-Henry says, "Play is honest. You can't play unless you are yourself."[2] When we pray, God wants us to be ourselves, not some image of ourselves, but the real thing. Playfulness can take us to a place of honesty and allow us to temporarily drop our external persona.

Teenagers are masters of the masked interior. They perch on the cusp between childhood and adulthood, uncertain of where to stand. They know they want to have fun, but are unsure that it is still okay to *play*. In a recent workshop for a church youth group, teenagers created prayer drawings using the names of people that members of the group announced aloud. Each youth had a clipboard full of paper and several markers in a color scheme they chose. The exercise began with a bit of silliness when the first name called out was the Tigers, the hometown basketball team vying with 63 other colleges for the NCAA title. That was a safe, adolescent choice—nothing too personal

or intense. The group wanted Victory for the team, plain and simple. A couple of the kids then suggested that maybe safety, healthy and drug-free living, good sportsmanship, and passing grades should also be part of their intercessions for the team. They spent several minutes in silence drawing and coloring their shape with the Tigers as the focus of the prayer.

The next name, which came after some hesitation, was one teen's distant relative with cancer, someone whom no one else in the group knew. The group loosened up a bit and the willingness to call out prayer requests came more quickly after that. As we added names, the requests became more personal, until they finally chorused the name of one of their own—a member of the group who had been hospitalized for depression.

When we wrapped up our time together, each teenager had a page full of prayer shapes. One girl announced that when she looked at her drawing she saw a dragon—"A prayer dragon!" she cried. We all cheered. It was a playful but powerful image. Several of the other members of the group shared their drawings while we oohed and aahed. Some of the drawings may have even found their way to the refrigerator, computer, bathroom mirror, or notebook cover for further attention and prayerful consideration.

I have no doubt that what transpired in that room was prayer—the creation of a space in heart and time where God could poke in and be present. At the beginning we invited the Holy Spirit to be among us. The teenagers entered together into the quiet of the exercise. They chattered and laughed some, but not in an attempt to disrupt. They were just being themselves. We moved from silliness to solemnity to lightheartedness. It was both prayer and play.

Playfulness and joy are not just for children and teenagers. The biblical writers witnessed to an understanding of this concept in the frequency with which they used the word *delight* in their writings. This word is used

throughout Scripture to describe our relationship to God. The Psalms are full of the word.

> "Take delight in the LORD, and he will give you the
> desires of your heart." (Ps. 37:4 NRSV)

> "Will they take delight in the Almighty? Will they call upon
> God at all times?" (Job 27:10 NRSV)

> "I delight to do Your will, O my God, And Your law
> is within my heart." (Ps. 40:8 NKJV)

Delight is a sensual and playful word. It is more than just fun. It conjures up images of children frolicking in fields and splashing in puddles. Lovers use the word to express the unexpected pleasure they feel in the presence of the other. *Delight* is a word that indicates full-body joy—top to toes.

Isaiah's use of the word emphasizes the bodily experience connected with *delight*.

"Why do you spend your money for that which is not bread, and your labor for that which does not satisfy? Listen carefully to me, and eat what is good, and delight yourselves in rich food" (Isa. 55:2 NRSV).

Delight is a frilly and sumptuous word—maybe even too frilly and poetic for our dark and gritty world. My contemporaries and people younger than I am do not use the word. I remember my mother saying that someone was delightful or that a performance she had just seen was delightful. That was high praise. It suggested more than just a nice person or a good performance, but someone who transformed a room, someone who brought light into a moment of time and space. When C. S. Lewis chose *Turkish delight* as the candy of choice to lure a young boy into treachery in his classic *The Lion, the Witch, and the Wardrobe*, he probably knew that it would take a special

treat—one whose name promised irresistible pleasure and enjoyment—in order to tempt misbehavior.

One reason we are so scared to have fun, to delight, to have pleasure in our prayer time may be that while delight is a gift of the Spirit, it is also a tool of the devil. The Bible talks about those who *"delight* in lies" and *"delight* in war" (Ps. 62:4; Ps. 68:30 KJV). Since our delight in evil can be so titillating and perverse, it is easy to mistrust the emotion altogether. So we enter our prayer time with a caution and sobriety that cannot make us vulnerable to the powers of darkness.

Can we trust a prayer time that is enjoyable and not overly serious? We deal with serious issues when we pray, especially when we seek healing for people who suffer. We beg and moan and wail, but we also come to prayer believing that the miracle of God's presence will make everything well and whole. We have at least a little faith in the promise and possibility of something new. Otherwise we would not be there at all. *Delight* is the appropriate response to our acceptance of that promise. When Jesus assures us, ". . . whoever does not receive the kingdom of God as a little child will by no means enter it" (Mk. 10:15 NKJV), I think he is asking us, in part, to give up our businesslike concern for the details and to fling ourselves into the open arms of God.

When I draw as a way to enter prayer, I get to delight in my prayer and to feel God's delight that I am making an effort to pray. Prayer can be the heavy labor of my heart and mind where I am the foreman of a job site. Or prayer can be my joy and freedom, the place where I get to play in the presence of my Creator, where I get a taste of "the glorious liberty of being a child of God" (paraphrase of Rom. 8:21).

Chapter 5

Childlike Prayer

Besides the playfulness of drawing prayers, there are other aspects of this prayer form that qualify as childlike. Constant movement, scribbling, and coloring are all activities we associate with children. I have to quibble with Paul when he says: "When I was a child, I spoke like a child, I thought like a child, I reasoned like a child; when I became an adult, I put an end to childish ways" (1 Cor. 13:11 NRSV). There may be some areas of life in which this is appropriate and necessary—like one's behavior behind the wheel of a car—but even for adults, childish or childlike desires and hungers still drive many of our prayers.

Our need to be loved, to feel protected, and to know that someone will take care of us, and even the hope that someone will fix the ills of the universe are all childhood desires that we will never outlive. One might argue that we should try to move from being childish to childlike, but the passage suggests

43

that adults can leave the needs of childhood behind. In practice, I think the adult Paul just found new ways of addressing his childhood needs, ways that he learned from imitating Jesus and his disciples. Unfortunately, Christians have read passages like this as encouraging them to leave behind the drama and playfulness of childhood prayer for adult forms of prayer that can only be called "heady."

Most of my life I have prayed with the top seven inches of my body—the 1,450 cubic centimeters we call the brain. Prayer consisted of corralling respectable and respectful thoughts into comprehendible words and sentences. Most often it was done sitting down in silence with closed eyes. But my body has always rebelled against those parameters. It likes to move. Most bodies like to move. The body does not want to be rejected as the less "spiritual" part of our being. Traditional methods of entering into prayer and seeking stillness are very difficult for me and other "movers." If I try to sit in a straight chair, fold my hands, and breathe deeply, my body rebels. I try to "be still and listen," but the body gets in the way. "You are not pure spirit," it says. "I want in on this God-time, too." The whole package of our being deserves to enter into prayer. Although many spiritual teachers, preachers, and gurus encourage physical stillness as a way to enter prayer, many bodies don't work that way.

If I permit my body to move—even just the movement of my hand, fingers, and arm with pen and marker—then my bones and muscles are content. I can become calm and relaxed enough to find inner stillness and to pay attention.

In general, it's not my body that needs to be stilled; it's my mind. Frank Zappa claimed a similar sentiment in one of his songs from the 1960s called "What's the Ugliest Part of Your Body?" He said it isn't the nose or the toes; the *mind* is the ugliest part of the body.

When I dance or walk or draw, my mind has half a chance at stillness. I'm not out to condemn the mind; most of us spend a lot of time there and we should. What I'm out to do is avoid the spiritual-versus-physical split between mind and body. This is particularly important for Christians. Fr. Richard Rohr, a Franciscan and a priest, was the first person to verbalize for me the spiritual danger of the split. He said something to the effect that evil scores a great victory when we hate the flesh. If we hate flesh, how can we possibly believe in the Incarnation? Since, by God's design, flesh was good enough for Jesus, we should stop hiding it in the basement when we invite God into our house in prayer.

"All spiritual disciplines are physical and are about being in your body, not escaping it," says Phil Porter in his book *Having It All: Body, Mind, Heart, & Spirit Together Again at Last*.[3] When we relegate the spirit to our thoughts and mind alone, we have cut off tens of thousands of cubic centimeters through which God can enter our lives. After Rabbi Abraham Joshua Heschel marched with the Rev. Martin Luther King, Jr., in Selma, Alabama, in 1963, he said, "When I marched in Selma, my feet were praying." Our feet, our hands, our toes, our nose, not just the brain, can become ports of entry for the Holy Spirit.

Another childlike characteristic of praying in color is that it is visual and colorful. No words are necessary. Even when verbal prayers bubble up, the combination of words and images make a lasting impression that the alphabet alone cannot.

My earliest memories of reciting the Lord's Prayer are visual. I *saw* the prayer laid out on stair steps in the middle of a dark solar system dappled with stars (a recurring scenario in my spiritual imagination). I ascended the stairs with each sentence or phrase until the "forever and ever" trailed beyond my view. My prayers from early in life were seen as well as said.

Praying with colored markers and pencils is not at all reminiscent of my own childhood religious training. In the church tradition in which I grew up, we did not color pictures of Jesus or connect dot-to-dots of Noah's Ark. We talked about theology and spiritual ideas. There was no time for childish play in the serious business of understanding God. Even my friends who grew up in Sunday schools that treated children like children soon "put away childish things"—their crayon renderings of men in bathrobes and beards, their role plays and simple songs—and relegated their spiritual life to the confines of their minds. It feels like another lovely kind of irony that this new prayer form requires no words. I, who felt superior to my Jesus-coloring playmates, now spend time almost every day coloring pictures with Jesus.

Chapter 6

Barriers to New Paths of Prayer

There are many reasons to avoid a new prayer form and many voices that tell us to maintain the status quo. Fear, superstition, and a need for permission are three of the difficult barriers to a new path of prayer. Like every other Christian I know, I have my collection of memorized, verbal prayers that have a parental or clerical imprimatur; I say them in the morning, at meals, in church, and at bedtime. On occasion, I can even extemporize or improvise an arrow-sized (rather than dart-sized) prayer that will express the depth of my need or desire. But outside of the "prayer with traditional words" framework, I'm often scared that I don't know how, that I'll violate some magical prayer code, that there are only certain acceptable ways to pray, that God or my mother will disapprove, that my efforts will be horribly flawed and imperfect, and worse, that I'll look stupid—even if it's just in front of myself and God.

The emotions and fears I describe are not unlike those of the students in my math classes. As a math professor, I meet students who suffer from what we in academia call Math Anxiety. It's like a psychological, allergic reaction to math—a panic attack in the face of pages full of numbers and equations. Students with this diagnosis come to class with their personal mathematical history. You can see it by the burdened way they carry their backpacks, the seats they choose closest to the door, and the narrow-eyed glares they give the professor.

Some of us respond the same way to prayer. We want to learn to pray or change the way we pray, but the prospect is daunting and embarrassing. Our anxiety is high. But as I tell my students, just because you couldn't solve an equation in junior high doesn't mean you can't do it now. And just because you couldn't pray at age fourteen or forty-eight doesn't mean you can't do it now. That was light-years ago, lifetimes ago—even if it was just last week.

Adopting a new way of praying may require a *suspension of rigid belief*. Most of us have a tendency to enshrine our narrow beliefs and spiritual practices. We assume that the way we learned to pray as a child, at one of our many conversions, or during a major epiphany about life is the only way there is. It worked then, so why change it? At the very least, this assumption reeks of superstition and fear. At its worst it might be arrogant and narcissistic. Holding and worshiping the stone tablet of my "I've always done it this way" prayers is idolatry. We don't need to destroy the prayers, but we do need to smash their place on the high altar of our consciousness and our rigid dependency on them.

The same kinds of irrational superstitions that make us go out the same door we went in, avoid cracks in the sidewalk, or avoid the intriguing prime number 13 can haunt our prayer lives. As much as we know the difference in our heads, we often confuse prayer with magic. "Don't pray with your knees crossed or ask for patience or forget to say 'Amen.'"

Maybe that kind of fear and superstition are not part of your relationship to prayer. But if they are, don't wait for them to go away on their own. Don't wait until you're a mature believer or a psychologically whole person. Write yourself a permission slip (God has already signed it) to pray in a new way, to be a novice, to feel stupid, to proceed even if your palms are sweaty and your heart is racing. Remember, "If it's worth doing, it's worth doing poorly." Or said another way, "If it's worth doing, it's just worth doing." And praying is worth doing.

A new prayer form gives God an invitation and a new door to penetrate the locked cells of our hearts and minds. The negative voices come in many pitches. One that I hear is: "Drawing is baby stuff—get a *real* prayer life. Prayer doesn't require material objects to get in touch with the spiritual." Maybe not, but I'll always be a baby in prayer. Whenever I have thought I was really on top of my spiritual game, my life has been blown to smithereens. I'm back on my knees crawling like a toddler. If God hands me crayons, then I'll receive them as the gift of the head Magi and get to work.

God is full of surprises in all parts of our lives—in the people who become our friends, the jobs we choose or that choose us, and the prayers that work for us. Renee is a thinker, articulate and somewhat cynical. She runs a huge urban social service agency that requires her to be focused and unsentimental. When Renee came to a workshop on Praying in Color I thought, "She'll hate this." To my surprise, and maybe hers, it worked for her. As a Lenten discipline, she drew every day. It was the first time she had stuck with a practice for forty days. Her eyes lit up when she talked about the gel pens she used. She didn't need a plan; she just picked up a pen and started to draw. Not only was the practice relaxing and fun, it also seemed like important work. Her prayers and concentration mattered and somehow made a difference. For her aunt's eightieth birthday gift,

Renee drew and prayed an icon. Her aunt liked the drawing so much that it now lives in a frame.

Another voice or myth taunts, "This stuff is for women." If this feels like gender-specific prayer, buy male markers—battleship gray, khaki green, butch black, tool shed taupe, buffalo brown. . . . Do not let the sexist demon attack your male ego. For many centuries, paint and canvas were the property and work of men only.

One male friend, Jeff, said, "When I look at the back covers of my few surviving notebooks from high school and college, I realize that I am one of those people who have been 'praying in color' (or at least black and white) forever. Any place you look there are doodles, some simply designs, but others with names inside—the girl of my dreams or the girl who attracted my wrath in Chemistry that morning. Through it all, the sense which I never quite verbalized, was that there was an audience for my doodling, that what I was doodling was being shared with eyes not my own, registered somewhere or with Someone. What I was doing as I drew my boxes and triangles was not quite private but rather more like an offering up of unformed thoughts and, dare I say it?, feelings. I probably would not have called it prayer at the time because it didn't start with 'Our Father' and end with 'Amen.' But in retrospect, it was prayer—nonverbal and primitive and satisfying."

So grab your markers, colored pencils, gel pens, or charcoal, gentlemen, and pray in color.

"This takes so much time. I can *say* my prayers in ten minutes." Praying with marker and paper can take time—maybe a sitcom or soap opera segment of time (and far more worth it). One of the reasons I like to pray this way is that I don't notice the passage of time. Any method of prayer or meditation that can get me to be still, to be present, and to be focused on something

other than my own life is worth the time. But if ten minutes is what you have, then draw for ten minutes. Create your own express version.

The most obvious negative voice against this particular prayer form is "I can't draw." This voice demands competence in all things. If you can scribble or draw a lopsided shape, you can pray in color. Participation, not perfection, is the only requirement. People who are not "writers" keep journals, write e-mails, and make shopping lists. We do these things for clarification, conversation, and communication, not to write a prize-winning piece of literature. Our goals for prayer are similar. We want communication and conversation with God. We want to clarify what's going on in our lives and seek guidance.

Unless you are more spiritually and psychologically whole than I am, the negative voices and the distractions will come. Call them evil, demonic, or just distracting, but don't let them keep you from a new path to God. These voices want you to think that there are no new ways to know God. Deal with them at the onset. Name them as the voice of the Liar. Make a preemptive strike and let them know that they will not deter you. Give them the heave-ho that Peter received when he tried to distract Jesus: "Get thee behind me, Satan" (Mt. 16:23 KJV).

Chapter 7

Other Ways to Begin

At some point, praying with the same icon or drawing may become rote. New people and concerns may ask for your time and attention. Since the process of drawing is half of the prayer form, it's time to start over. There are an infinite number of ways to start drawing. Start with something as simple as a line.

Add flags or blossoms for names.

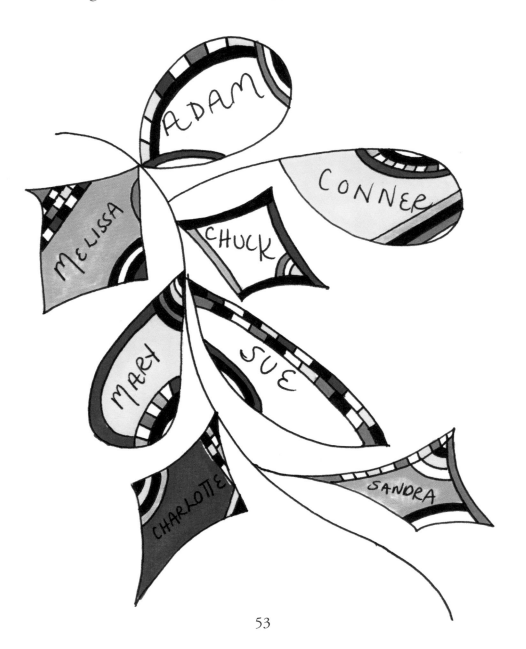

3

Write a person's name and let the name instigate the movement and shape of the drawing.

Praying in Color

Holidays or seasons can inspire shapes or colors.

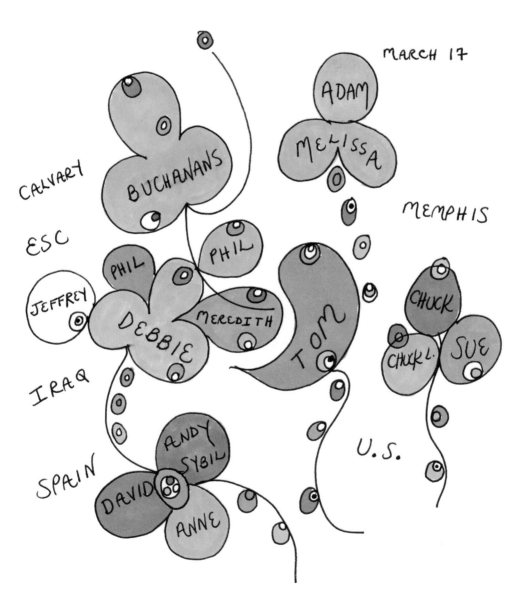

Even a grid can host the people you want to pray for. The advantage of the grid is that there is built-in room for more names.

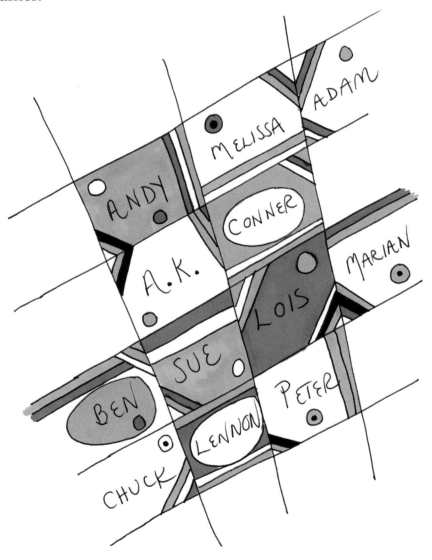

The hand, given free rein, will often create a wacky drawing.

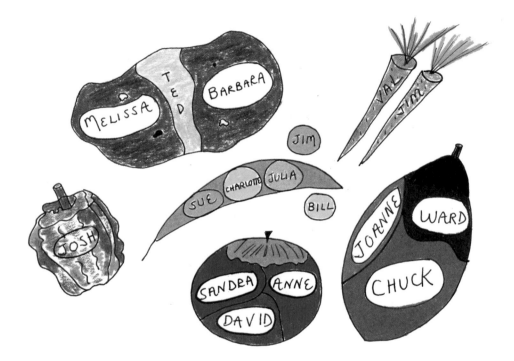

The first shape I drew looked like a potato, so everyone that day ended up inside of a vegetable. The downside of such a drawing is that friends might think you are bit crazy if you tell them, "I prayed for you today and you were in an eggplant."

The upside for me was that I really remembered who I was praying for and where they were on the page. The whole point is to flood the memory with visual reminders and trigger unceasing prayer.

The word *irreverent* entered my mind as I drew. Intercessory prayer is serious and solemn work, but it can also be joyful and playful. When I pray, I release the burdens of my heart. Lightness replaces despair and sorrow.

Sometimes color feels unnecessary or wrong. Draw with just black pen and ink.

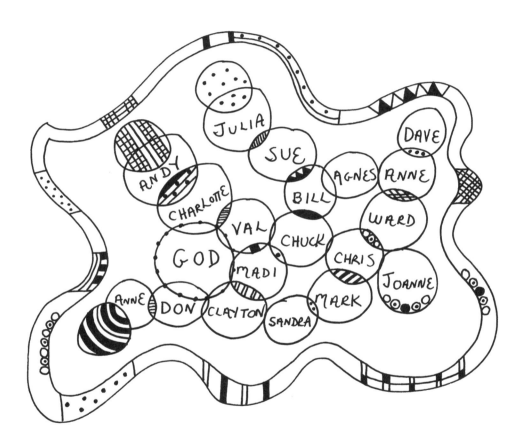

There are times when I've been too sad or too hurried to pick up the colored markers. Instead of trying to force myself to add color, I gave myself permission to just use pen. The result can be as distinctive and memorable as color.

There may be times when one person or one family is the focus of your love and concern. Don't hesitate to devote an entire drawing to a single person.

The image of God as a patchwork quilt came from my son when he was three years old. He described God as patches of every kind of skin, fur, shell, and feather of all creatures on earth. It seemed appropriate when I prayed for him that he be wrapped in a picture of that quilt.

Chapter 8

Examples of Other Prayer Icons

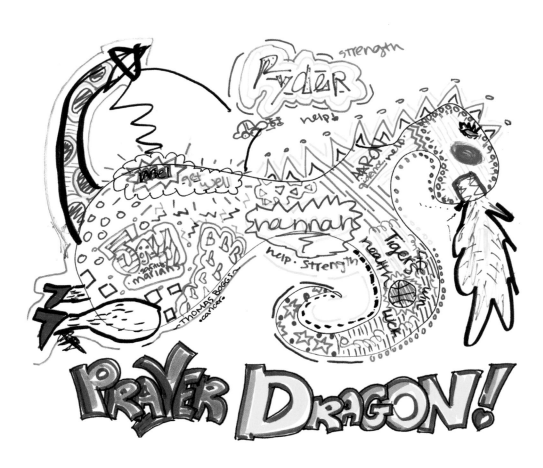

3

3

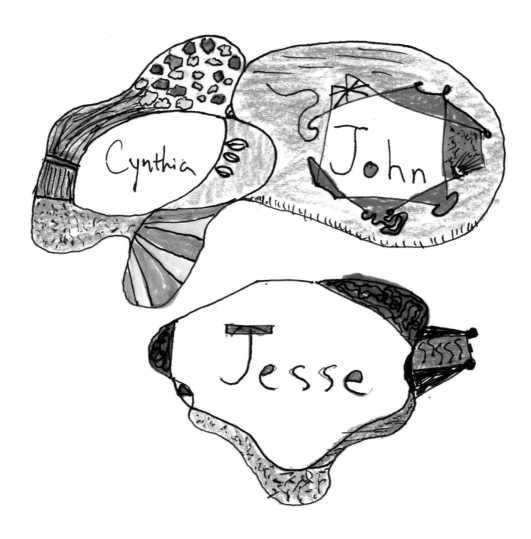

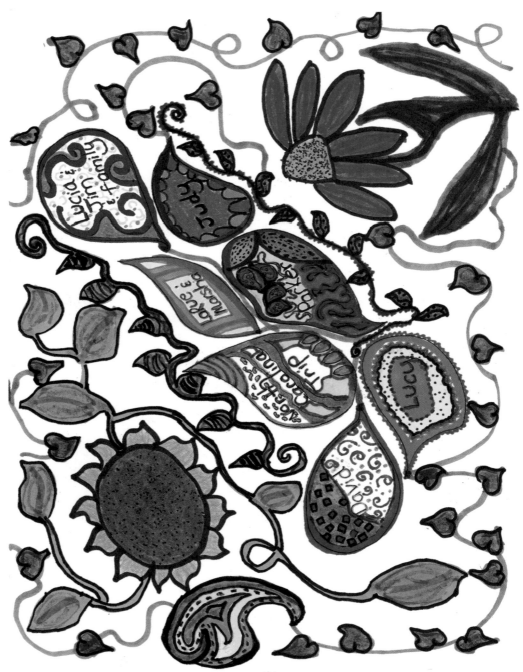

Part 4 Using Color to Pray...

Chapter 9

In Other Ways

Although intercession was the struggle that inspired Praying in Color, there are other kinds of prayer and spiritual brainstorming that fit well into this form. The possible ways to use this practice are as endless as our needs and our imagination. Here are some other ways to pray in color.

Compost prayers

God can handle whatever we bring to prayer. Some days we just want to dump all of our complaints, whining, grumpiness, and misery on God. Have at it! Write all of the negative things you can think of on your prayer drawing. Don't hold back. God can take our garbage and turn it into compost. Hang onto the prayer for a day, a week, or a month; then, if you have a compost pile, bury it there.

Thanksgivings

Fill the page with the many things for which you are thankful. A gratitude icon and a compost prayer icon go hand in hand. We can be grateful and grumpy with a God in whom we trust. Listing our grievances

67

one time and our thanksgivings another shows an effort to have an honest and intimate relationship.

Amends

Think of the people to whom you need to make amends, to make apologies, or to ask for forgiveness. Write the names of these persons and the wrongs committed. Use the prayer drawing as a way to rehearse making the amends or apologies. Doing this in person may or may not ever be possible, but the act of confessing on paper might result in unexpected resolution. When we invite God into the process, clarity and cleansing can happen.

Spiritual Journey or History

Create a drawing that is a map of your personal journey with God. Include small, seemingly unimportant flickers of God as well as soul-blasting conversion experiences. Each step will probably trigger other memories and help you see other ways your life has been infused with God's presence.

Mentors

Catalog and celebrate the people who have helped you in your spiritual life. Sunday school teachers or pastors might be on the list, but think of the less obvious people who have helped you to see yourself as a love-worthy child of God. Sometimes mentors are the people who tell us the truth: a teacher who has kicked us off our complacent duffs or a friend who tells us we are acting like a turkey.

Remember adults who have encouraged us in a way that our parents could not. Sometimes other adults can see our gifts in a way that our own parents cannot. Parents are often scared for their children's safety and want to maintain the status quo. They want other people's children to become poets

or social workers or relief workers in the Sudan. As a parent I understand the fear. As a child I wanted to be able to dream myself into a whole host of uncertain vocations. Other adults, either because of their particular expertise or because they saw us anew, might have helped us envision ourselves in new ways.

Personal Mission Statement
Use words, drawing, and color to help verbalize and visualize who you are, whose you are, and what is important to you.

Healing of Memories
Most of us harbor old wounds and hurts that keep us bound and resentful. Use this process to articulate those wounds, to face them, and to face them down.

Names for God
Put some or all of the names we call God in your drawing. Let the drawing become a meditation on the way we understand and expand our knowledge of God. Maybe a particular name will speak to you.

Vocabulary
Christianity has its own jargon. Sit with a word or words from your tradition. Words like *salvation, forgiveness, incarnation, sacrifice*—loaded and heavy words.

The following pages show even more ways to use this practice.

Chapter 10

With Scripture

Learn and memorize a passage from Scripture.

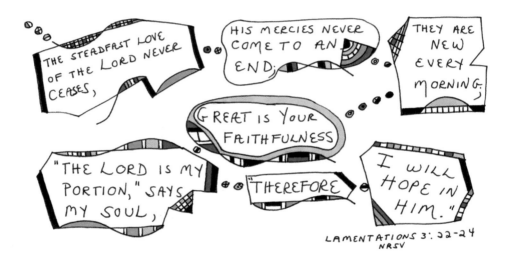

THE STEADFAST LOVE OF THE LORD NEVER CEASES,

HIS MERCIES NEVER COME TO AN END;

THEY ARE NEW EVERY MORNING;

GREAT IS YOUR FAITHFULNESS

"THE LORD IS MY PORTION," SAYS MY SOUL,

THEREFORE

I WILL HOPE IN HIM."

LAMENTATIONS 3: 22-24
NRSV

Write the first sentence or verse of the passage you want to memorize. Say it over and over again while you enhance the words with designs and color. When you can recite the words with ease and can visualize the words on the paper, move to the next verse.

When the new verse feels comfortable, put it together with the first verse. Say the two together moving your eyes back and forth across the drawing. Continue the process until you have committed the entire passage to memory. This might take more than one sitting.

Use the form to explore a word from Scripture.

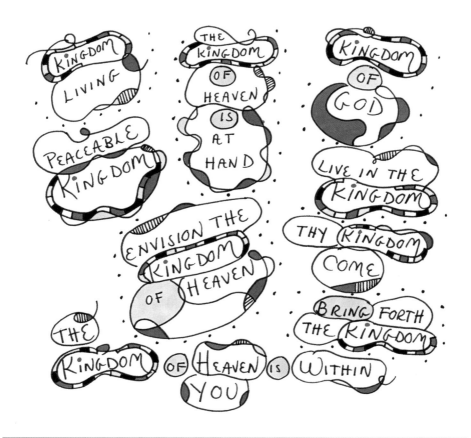

The word *kingdom* is a loaded word. It gives fairy tale images of "happily ever after" and security as well as images of evil rulers, wars, feudalism, and disparity of wealth.

The exercise of writing down sayings with the word *kingdom* in them didn't resolve anything for me, but it did let uses of the word float before my eyes and consciousness. *Kingdom* is a central concept of my spiritual imagination and of the biblical culture of promise and hope.

Pray the Scriptures using LECTIO DIVINA

I read the Bible to learn lots of things: the faith and history of my religious ancestors, verses of inspiration and wisdom, the nature of God, and the tenets and laws by which the people of God framed their lives. I can *learn* lots of things from the Bible. It's full of *information.* But the real reason I read the Bible is not for its facts or history or laws, but for its truth. I want the Bible to speak to me. I want it to *speak its truth* (a Parker Palmer phrase)[4] to me. *Transformation* is the goal of my relationship with Scripture. I want it to put me on the path of salvation and turn me into a person of God. And that goes way beyond learning facts.

I like to think of Scripture as the love letters between God and God's people, not a how-to or self-help book. It is about the promises and commitments between the God of salvation history and God's beloved human creatures. What do those promises and commitments have to say to me today? Sometimes I suspect that God does want me to review the Ten Commandments because my behavior is off base and I've forgotten who and what I am. It's probably important to take a monthly quiz. But beyond that, I want to be absorbed into the mystery of God. It's too easy to say, "I read the Bible, I swallowed it, and the meal is over." Scripture is not that tame, and God's voice is too large to be confined within 1,500+ pages of a book.

One way that helps me to sit and listen to Scripture, in the same way that I can now sit in intercessory prayer, is a variation of an ancient Christian practice called *lectio divina,* or *divine reading.* It is a way to "be with" Scripture and to let it transform us. It is not a historical study or critical analysis of Scripture or even our interpretation or understanding of it, but a way to *pray* the Scriptures and to listen for the voice of God speaking to us, with us, and in us in a particular way on a particular day. It is a prayer to hear God speak God's truth through Scripture.

Lectio divina is a four-part prayer form—*Lectio, Meditatio, Oratio*, and *Contemplatio*. The Latin words roughly translate as Read, Meditate, Speak or Pray, and Contemplate.

Most of the books about *lectio divina*, both old and new, talk about ways to prepare for this prayer practice. They include many of the things that are difficult for me—silence, stillness, straight spine, hands placed in the lap with palms up. . . . So with apologies to the monks and Desert Fathers and Mothers of old, this version will combine traditional practice with techniques of Praying in Color in order to accommodate the needs of the silence- and stillness-challenged. So for *lectio divina* in its colorized variation, gather your markers, pencils, or pens, and prepare your prayer place.

The first part, LECTIO, is the reading of a short passage of Scripture, a few verses at the most. You can choose a familiar passage, a challenging or troubling one, or a new one. If you're stuck for a choice, the Daily Lectionary is a good place to start. It is a collection of daily readings that include a Psalm, an Old Testament lesson, a Gospel reading, and a New Testament lesson. Google "Daily Lectionary" online and you will get many hits. Many denominations and publications have their own version of daily Bible readings. You can find the Daily Office Lectionary in the Book of Common Prayer as a two-year cycle. (In an even-numbered year, start Year One readings on the First Sunday of Advent.)

To begin this version of *Lectio*, write the chosen passage on a piece of paper. Write it slowly and large enough for it to feel important.

Then read the passage. Read it slowly, over and over again, in silence or aloud. Read it five times or a dozen times, whatever it takes to let the words flutter into your consciousness. A word, several words, or a phrase may capture your attention. Highlight them or circle them.

Lectio: Write or type the passage from Scripture. Allow the words to fill the page. Read the words slowly. Read the passage over and over again. Highlight or circle the words that speak to you.

LET NOTHING BE DONE THROUGH STRIFE OR VAINGLORY; BUT IN LOWLINESS OF MIND LET EACH ESTEEM OTHER BETTER THAN THEMSELVES.

PHILIPPIANS 2:3 KJV

MEDITATIO means to meditate or "mull over." In culinary terms, we "chew" on the words. Imagine yourself in a nice restaurant without chores, bedtimes, or meetings facing you after dinner. Instead of just wolfing down the food, you have time to savor it and enjoy the experience of taste. This is the way we approach the words in a *lectio divina* practice.

Write the highlighted word or words on another piece of paper. If they are not part of a phrase, place them in different spots on the page. To still your mind, make a drawing around each word. Don't start analyzing the words. Just sit with them in the same way you did when you drew an intercessory prayer icon. Let them unfold and speak to you. In Psalm 119:130, the psalmist says, "The unfolding of your words gives light; it imparts understanding to the simple" (NRSV). Treat the word as if it is a guest and you are a polite host waiting for it to speak or deliver an important message to you. (In reality God, the Host, has invited us into prayer, but the analogy works to describe our presence with the word!)

How and what God speaks through the words will be different for each of us. The words might summon visual images of the biblical passage or scenes from our life. The words might meander through our personal thoughts and concerns and cause an "Aha!" moment where we see something more clearly. Fr. Luke Dysinger, O.S.B., says, "[W]e must . . . allow it [the word] to interact with our thoughts, our hopes, our memories, our desires." The word can jab us in our hearts, our minds, our nose, our toes . . . because it interacts with our whole being. What we hear might be comforting or convicting. Continue to draw and color the words as they become part of you. If some powerful thought comes to you, don't be afraid to write it on the page.

If your absorption rate is slow like mine, the word might still be soaking into your pores later in the day, week, or year when you hear God's truth speak to you. Try not to force meaning or a voice; remain as a host. For people of the

twenty-first century who need a goal and a product, it is difficult to come out "empty-handed" in the traditional sense. Even the goals of being a "better" Christian or a "better" pray-er or more in tune with God's voice have a consumer-marketing feel about them. *Lectio divina* is about God and the vastness of God's love. The focus is not to be on us or on our self-improvement.

Meditatio: Write your chosen words on another page. Draw around or near the words. Let them be honored guests. Be patient and listen for the wisdom they deliver.

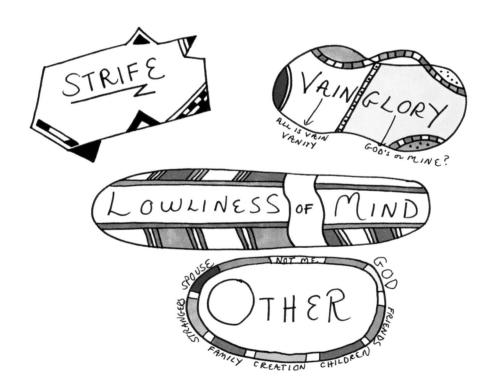

When you have listened to the word speak and watched the images it displayed, move to ORATIO. In this step we release the *word* of God and pray to *the Word* who is God. *Oratio* is our heartfelt response to the personal inklings of God we received in *Lectio* and *Meditatio*. Our response might involve conversation and questions about the words on our paper. We might ask, "Why are these words important for me today?" But *Oratio* is also about feelings and intimacy—the tender crosstalk between Creator and creature. In *Oratio* we open ourselves to the daunting possibility of knowing God's love for us and feeling God's presence within us.

This is a welcome time for some of us. We are happy to express our love and feelings for God. But for those of us who are not so comfortable with feelings and a personal relationship with God, this can be a scary step. Understanding God as lawgiver is easier than God as lover. The words of Scripture can be either the avenue to knowing God or the dead end that keeps God at bay. In *Oratio*, God invites us into a relationship beyond obedience and awe, a chance to know and be known. If you are frightened or turned off by this intimate stage of *lectio divina*, take heart. You don't have to get gushy with God. You don't have to profess your adoration or love. Silence is always an option.

Whether you are comfortable or uncomfortable with this step, one way to respond is with pen and marker. Let your feelings, questions, and prayers come to the surface. Write them down and offer them to God. "I don't know how to love you or if I love you." "Thank you, God, for your words." "Why these words today?" "Open my heart." "Help my unbelief." "I love you so." "I am scared." Don't analyze. Just write. This is the time for honesty and trust; I believe God longs for that from us. "The LORD is near to all who call upon him, to all who call upon him in truth" (Ps. 145:18 NIV).

If one of those words or statements seems poignant to the moment, corner it with pen and color. Listen while you draw. Conversation is the

Oratio: Engage God in conversation. Open your heart. Ask questions and reveal your feelings. Write them down. Choose the word or words that seem most important for you now. Sit with them and draw.

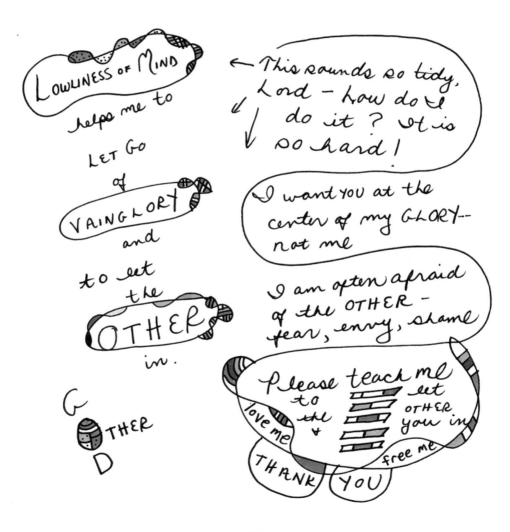

LOWLINESS OF MIND helps me to LET GO of VAINGLORY and to let the OTHER in.

G OTHER D

← This sounds so tidy, Lord — how do I do it? It is so hard!

I want YOU at the center of my GLORY— not me

I am often afraid of the OTHER — fear, envy, shame

Please teach me to let the OTHER you in love me free me

THANK YOU

back-and-forth between two participants. In prayer, it sometimes feels as if it's all "forth"; we do the talking. We hope for something "back." And we want it now. The "back," however, comes in God's own time—in an almost audible voice, in an ordinary thought later on, in a dream, in the affirmation of a community, or with a gentle nudge or rustle of knowing. Being present with God in *Oratio* prepares the soil of our heart to receive the response when it comes.

CONTEMPLATIO, the last step of *lectio divina*, is the rest stop. We give up all of the activity of the earlier steps—the words of Scripture, the "mulling over," the prayers, the thoughts, the feelings, the desires of our heart, the expectations, and maybe even the drawing. By this time in our *lectio divina*, we have been prepared for rest.

This is the hardest step for me, because I want something to happen. I want to have a religious experience to top off my prayer time—an end-of-meal surprise, a spiritual tiramisu! I think, "This is the time to be empty, so God can come in." But the statement itself expresses my expectation, my need to control God. So I imagine myself in God's presence with no agenda and then release even that image. My friend Phyllis Tickle describes God as the "luminous all-receiving dark." The challenge in *Contemplatio* is to experience the "dark" and that elusive thing called inner stillness, where God is there and I am there and transformation sometimes happens. But transformation or not, the rest prepares me to return to my daily life renewed by the words and the Word. *(see art on page 80)*

Contemplatio: This is the time to release the work of the previous steps and rest. Let go of thoughts and feelings. Enter into a still place. Breathe evenly. If you're distracted by your body, draw with your eyes closed. Let the movement of the pen bring your mind to rest.

Save the sheets of paper with your prayer drawings on them. Put them where you can see them or where they are accessible. Store them in a notebook as a prayer journal. When we learn something from a prayer time, it usually takes a long time before we incorporate our insights and gleanings into our lives. Having a visual reminder of the words may speed up that process.

Lectio divina is a practice that takes practice. Do it a dozen times without asking, "Is this useful?" Prayer is not just about application and utility; it's about living full-time with God at the center. *Lectio divina* reminds us that living as a person of God is not about "getting" or "doing," it's about "being" in relationship with God. All actions are a subset of that relationship.

In his book *Read, Think, Pray, Live*, Tony Jones suggests a 30-minute *lectio divina*: 10 minutes for *Lectio*, 5 minutes for *Meditatio*, 10 minutes for *Oratio*, and 5 minutes for *Contemplatio*.[5] This is a helpful guideline, especially if the movement from one step to another does not seem obvious. On your first attempts, thirty minutes might seem like too much time. Build up to it gradually. Cut each of the suggested times in half at first. Soon, you just may find yourself hungry for more!

Chapter 11

For Remembering

Use this form for reflecting on important concepts and ideas that you read or hear in books, keynote speeches, poems, or prayers.

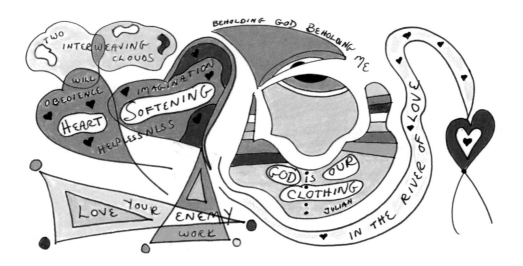

I drew this icon after a session with my spiritual director. I wanted a visual way to remember the things we had talked about and prayed about. The act of drawing and the resultant picture were far more helpful to me than a list of words.

Chapter 12

For Discernment

We can find help for our discernment and decision-making by visualizing the issues we face and releasing them as prayers.

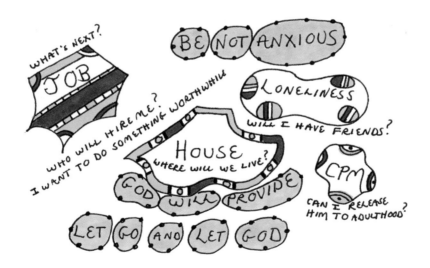

When my husband and I made a decision to move to a new state and a new job, we were fairly certain that we had made the right decision. However, the details and anxieties of leaving our young-adult son and a home where we had lived for sixteen years were overwhelming. The process of drawing and writing helped to calm my worries.

Explore questions, dilemmas, and values.

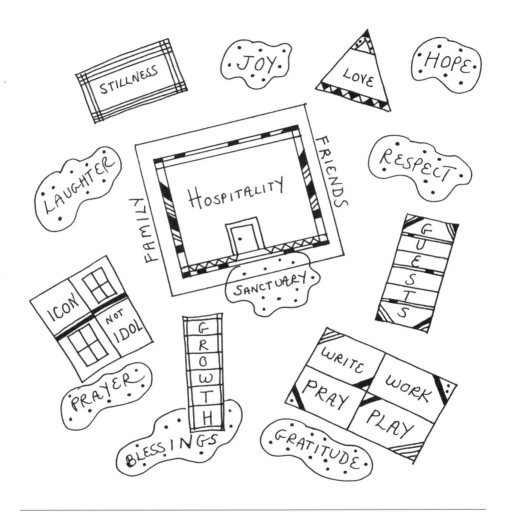

In the process of looking for a place to live after a move, it was so easy to get caught up in square footage, number of bathrooms, kitchen accoutrements, and landscape. The drawing helped me to explore what I really wanted in a *home*.

Catalog your gifts, your shortcomings, or your dreams.

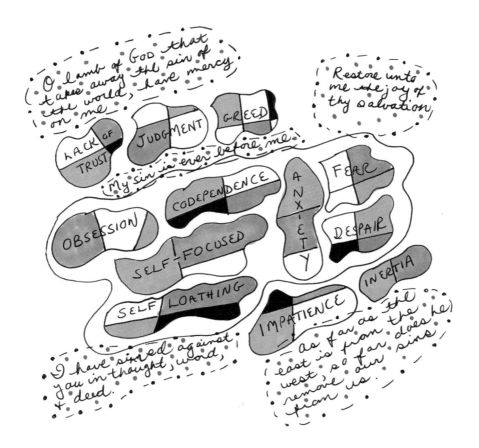

Within the illustration:

O lamb of God that takes away the sin of the world, have mercy on me

Restore unto me the joy of thy salvation

LACK OF TRUST

JUDGMENT

GREED

My sin is ever before me

CODEPENDENCE

ANXIETY

FEAR

OBSESSION

SELF-FOCUSED

DESPAIR

SELF LOATHING

IMPATIENCE

INERTIA

I have sinned against you in thought, word, + deed.

as far as the east is from the west, so far does he remove our sins from us.

During Lent one year, I was feeling an appropriate amount of self-disgust. Listing my sins and character defects was a cleansing exercise. Words popped onto the page that I had never associated with myself before.

"What gets buried, gets buried alive," someone much wiser than I said. Digging up the unlovely parts of myself and exposing them to the light of day in an aura of prayer have, I hope, given them less power to control me.

Chapter 13

With Calendars

During the forty days of Lent, try one of these prayer disciplines: Pray for people, places, or situations that are not part of your normal everyday prayer life. Read the Gospel lesson each day from the Daily Lectionary and reflect on a single word (a drive-thru version of *lectio divina*). Reflect on the seven deadly sins for five or six days each—pride, envy, anger, sloth, greed, gluttony, and lust.

Draw on an actual calendar starting with Ash Wednesday. Use one of those ubiquitous calendars from an insurance company or a funeral home. The small size makes a 40-day discipline seem doable. You can also download a calendar from the Web or create one on your computer using a table feature. You get to decide the size of the boxes.

Make a 40-day booklet with all of your prayers. Each day pray for a different country, person in the government, or problem facing the world.

Monday	Tuesday	Wednesday	Thursday

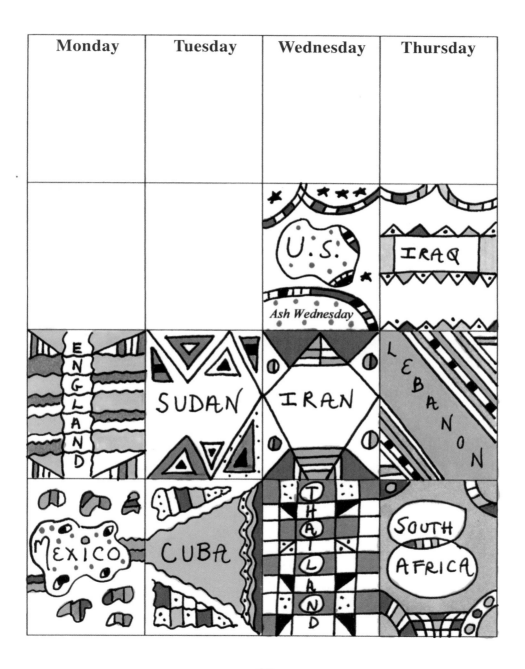

Create an intercessory Advent Calendar. Add a new person each day.

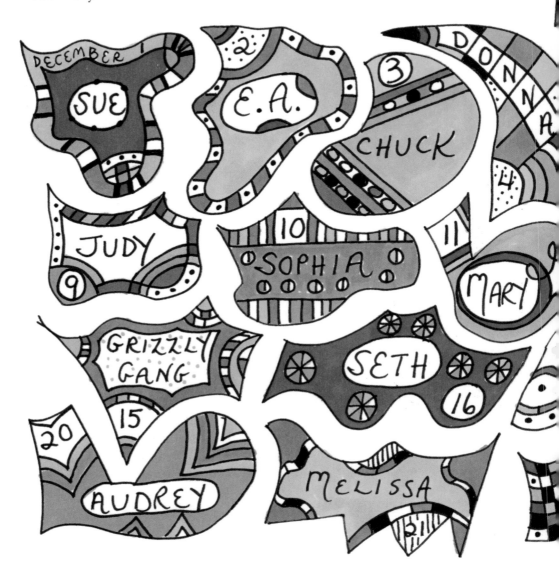

Chapter 14

For Our Enemies

Praying for others is an act of hospitality. It involves opening the door of our hearts and minds and admitting people into our consciousness. We invite them to take up residence for a time and allow them to engage our feelings and thoughts. Like entertaining guests for a weekend, praying for others requires time and energy. It is a way of saying, "Yes, I will hang with you and support you in your challenges and your suffering."

In Matthew's Gospel Jesus tells us, "Love your enemies, bless them that curse you, do good to them that hate you, and pray for them which despitefully use you, and persecute you" (Mt. 5:44 KJV). Praying for his enemies was just another example of the radical hospitality that Jesus practiced. He invited people of questionable character and occupation to share meals with him. He let a woman—and even worse, a woman of sketchy repute—wash his feet

and rub them with oil. He touched and healed the unclean. He opened his heart and life to men, women, and children that we would not even notice on the street.

Praying for our friends and loved ones is one thing. Offering the same kind of hospitality to our enemies is a lot to ask. Praying for the people who irk us, the people who hurt us, or the people we dislike or even hate is difficult because we do not want to think about them, let alone permit them to enter the sacred privacy of our prayers. We want to avoid our enemies, to forget that they exist. Even saying their names gives them a prestige we do not want them to have. Hospitality is out of the question.

When my husband and I moved to a new house in a new town some years ago, my next-door neighbor was all about hospitality in the traditional sense of the word. She brought us brownies within hours of our arrival. She offered us tools, meals, a chaise lounge in her backyard—anything that would make us feel welcome and ease the hassles of moving.

In the first weeks after our move, I noticed a parade of people coming to her house. She hosted a prayer group, a Third Order Franciscan gathering, and meetings of social justice committees. A fascinating assortment of individuals came for prayer and spiritual direction. What I didn't know then was who else she had invited into her life.

At age 94, my neighbor's great aunt was raped and murdered. She had walked in on the burglary of her apartment and was stabbed multiple times. The man responsible was convicted of first-degree murder and sentenced to death. For thirty years, he has been on death row. For thirty years my neighbor has prayed for him. Those prayers led her to initiate communication with him. Over the years they have exchanged letters. She has visited him at the state penitentiary. Her encouragement has led him to write and publish poetry.

My neighbor's hospitality has changed her life. She could have opted to blot the event out of her mind. She could have cultivated a justifiable hatred for the man who murdered a beloved relative. But she didn't. Her prayers and her efforts have resulted in several stays of execution and a resentencing hearing. She now speaks in public against capital punishment.

My neighbor's hospitality has also changed the man in prison. He has not become a saint or a man we would want as a neighbor, but he has been seen as someone worthy of the prayers and time of another human being. From a Christian as well as a quantum physics perspective, the way we as observers see something changes the observed. Just by looking at a quark, an atom, or a person, we alter them. Seeing a person as a child of God and praying for them changes both the person we pray for and us in ways that we cannot plan or predict.

Using markers and pen does not make praying for enemies easier than other prayer practices. It will probably not feel at all relaxing or playful. Writing the names of people you dislike or who "spitefully use you and persecute you" (Mt. 5:44 NKJV) can be a big step. It may turn your stomach. Unlike the verbal prayers you say, the name does not vanish into the past once it has been spoken. It sits on the page and stares back at you as you draw and color. Instead of the person's name, you can also write initials or a coded version of the name. In case someone stumbles on your prayer drawing, this can protect the anonymity of the person as well as your feelings.

When my neighbor prays for her enemies, she makes two columns on a piece of paper, one for the left brain (the analytical and logical side) and one for the right brain (the intuitive and creative side). In the right-hand column she puts the person's initials or code name and draws. When thoughts or words come into her head about the person, she jots them down in the

left-hand column. These might include feelings, things to dislike about the person, or things to admire about the person.

Negative and angry thoughts about the person may challenge your hospitality. Write them down; then arm yourself with a one-line prayer or Scripture passage to counter the challenges. Here are some examples:

"You strengthen me more and more; you enfold and comfort me." (Ps. 71:21 BCP)

"When we extend our hand to the enemy who is sinking in the abyss, God reaches out for both of us. . . ." (Thomas Merton[6])

"Forgive us our sins, for we also forgive everyone who sins against us." (Lk. 11:4 NIV)

"There is nothing I cannot do in the One who strengthens me." (Phil. 4:13 NJB)

". . . God shows his love for us in that while we were yet sinners Christ died for us." (Rom. 5:8 RSV)

You can say the words to yourself over and over as a mantra or write the words in one or both columns of the drawing.

When you are finished, if you can stand it, hang the icon in a prominent place. Whenever you see it, remember the person as a child of God. If the temptation comes to use it as a dartboard, shoot a dart prayer at it instead.

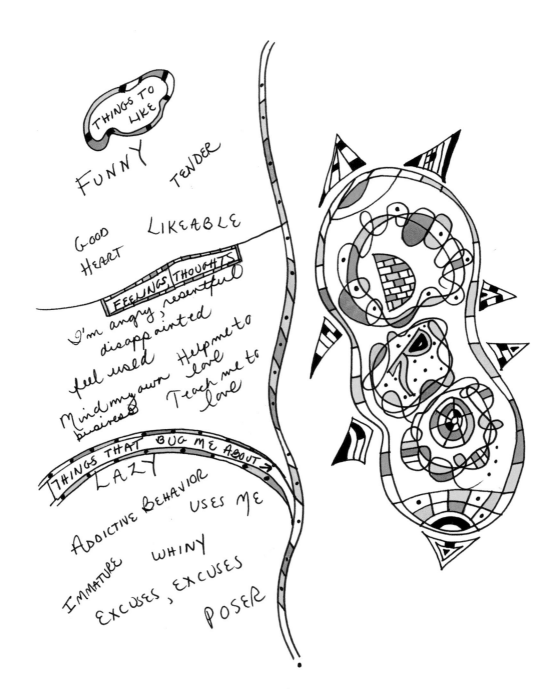

THINGS TO LIKE

FUNNY TENDER

GOOD LIKEABLE
HEART

FEELINGS | THOUGHTS

I'm angry, resentful
 disappointed
feel used Help me to
Mind my own love
business Teach me to
 love

THINGS THAT BUG ME ABOUT →
LAZY

ADDICTIVE BEHAVIOR USES ME

IMMATURE WHINY

EXCUSES, EXCUSES

POSER

Chapter 15

On the Computer

Between work, e-mail, Web searches, instant messaging, and games, many of us spend hours in front of the computer each day. The computer makes our tasks faster and easier. It also offers us the temptation to fritter away the hours of the day. The compulsion to check our e-mails, contact a friend, or Google some interesting subject can keep us from exercise, relationships, community service, prayer, and work. It is sometimes difficult to sort out the wheat from the chaff.

In an attempt to keep my priorities straight and my compulsions in check, on the first login of the day I read fixed-hour prayers. I go to the website www.explorefaith.org and look for "Pray the Divine Hours." What I find are prayers designed for the hours between 6 AM and 9 AM—one of the "seven times a day" that the psalmist suggests we praise God (Ps. 119:164 RSV). I spend three to five minutes reading a combination of Psalms, a Gospel reading, the Lord's Prayer, and other prayers and recitations. It reminds me that God comes first, even when the proportion of time spent in prayer pales next to my other activities on the computer. Actually, I can go back to

95

that site several times a day and find a new set of prayers for each three-hour period of the day.

It occurred to me one day that maybe I could "pray in color" on the computer. It started off as a frivolous notion, really. And then I tried it. I went to my word-processing program and pulled up the drawing tool. I picked a ready-made shape and typed in the name of someone on my prayer list. I attached other smaller shapes, lines, and designs. Another icon on the toolbar added fill color; another changed the color of the lines. Fifteen minutes of typing, clicking, copying, pasting, coloring, filling . . . and the result was a prayer drawing, or as I have come to call it, an icon.

It felt a little like cheating. My own hand had not drawn the shapes. They were perfect squares, ovals, and triangles. The coloring was regular and even. But what struck me was that the process had been meditative. The clicking and copying had a rhythm that settled me and helped me pay attention to the people I prayed for. I had hesitantly invited God into the process, and I felt as though the invitation had been accepted. It is an ongoing mystery to me that the Holy Spirit visits the most mundane of circumstances. Whenever we claim that God is eternally unchangeable, I wonder. Maybe one of God's unchangeable characteristics is adaptability. The One who "makes all things new" meets us wherever we can be found—even in the nano-spaces of our new and sometimes wacky innovations and diversions.

Praying on the computer feels a little different from drawing on paper. The whole idea seems just a little weird. But the bottom line is, "Have I prayed?" Have I spent intentional time in the presence of God praying for the people I care about? The comparison may be similar to reading a novel or listening to a novel on tape. Some people would argue that it doesn't count if you don't *read* the words yourself. Others would argue that listening requires a different kind of concentration that is no less sophisticated than seeing the words. Both involve a

journey with the end result of knowing the story. Praying on paper and praying on the computer both have a process and product that are of equal importance.

One advantage to drawing on the computer is that the result is then *on* the computer. If you spend hours a day near a computer, you have easy access to your drawings. You can print the finished drawing. You can save it in a folder labeled *Prayers*. Or instead of closing the file, just minimize it so you can pray throughout the day with just a single click. Or turn it into your screen saver of the week.

Having the icon on the computer is also a natural way to start a visual prayer chain. Send the prayers to other people via e-mail and ask them to pray also. Send icons back and forth across the ether, filling it with prayers for healing and blessing.

To get started, explore the various ways to draw on your computer. It might be that your word processor has a drawing utility within it, or you might have a separate application. Most of the computer programs I use have their own unique and irritating personalities to understand.

Becoming familiar with the possibilities before you draw and pray can make the process seem more like prayer—rather than just another steep step on the computer learning ladder and an exercise in frustration. Experiment with the ready-made shapes; you can stretch, shrink, rotate, or distort them. Fill in shapes with color or background patterns. Change the way a line looks by making it dashed or thicker. The program I use also has single- and double-ended arrows. Try the function that allows you to draw freehand or scribble. It takes some practice, but it feels more like drawing than clicking the mouse does.

The next section will walk you through a Praying in Color session on the computer. I have chosen the names, shapes, and colors for instructional simplicity. Feel free to make other selections. A first round of this might not feel much like praying. Over time, the drawing steps will become more automatic.

Start your prayer time using some of the suggestions on pages 22 and 23 in Chapter 2.

Find the rectangle icon. Click on it. Move it to the location on the page where you want it to be. Make it the size you want it to be.

Click on the rectangle. Select the textbox icon. The textbox will be inside of the rectangle. If not, move it inside of the rectangle. Change it to the desired size.

Click inside the textbox. Write the name of the person for whom you want to pray. Change the font, color, size, and position of the name. Choose a color or style of font that reminds you of the person. Or choose a color and font that will bring you joy or will keep your attention. Readjust the size of the textbox.

Click on the textbox and change the intensity and style of the outline. You can also change the color.

⬤ Click inside of the textbox and change the background or fill color.

◯ Click on the rectangle and change the border style and intensity. Change the background or fill color.

▷ Size the rectangle again, if desired. Use the icon or command that connects objects together. My program uses the word "Group." Group the textbox and the shape. This means: hold the shift button down, click on the rectangle and the text box, then hit the word "Group." This action enables you to pick up the whole design and move it to some other place on the page. It also makes copying and pasting easier.

⬚ Add other shapes to enhance the drawing and to spend more time in prayer for the person. For example, choose a circle. Copy the circle. Hit the paste button as many times as the number of circles you want.

Move the circles to different places on or near the drawing. Think of each click of the mouse as a prayer moment—kind of a divine ditto to say that the person is in God's hands.

Resize the circles and add fill color and patterns. When you are satisfied with this step, group all of the pieces together.

Add another round of circles of varying sizes. Group all of the pieces of the drawing together.

This may sound corny, but to me Jane seems less alone, surrounded by color and shape. The time we spend with her matters. It changes how we see her and how we see God. And our faith tells us that it changes Jane and us, as well.

Use some of the suggestions on page 30 to conclude your time with Jane and to move on to prayers for another person. The fact that you can still see "Jane" on the page will keep her in your continual prayers.

○ Add another person to your prayer drawing. This time choose the oval shape. Change the size and shape. Add the textbox and name.

⊛ For a little variation, click on the oval and rotate it. Click on the textbox and fill it with color. Change the color and style of border of the textbox or remove the border. Click on the oval and fill it with the same color as the textbox. Change the border of the oval. Group the textbox and oval together.

▷ Resize the grouped oval. Add additional detail and enhancement to the original shape. Group all of the shapes together.

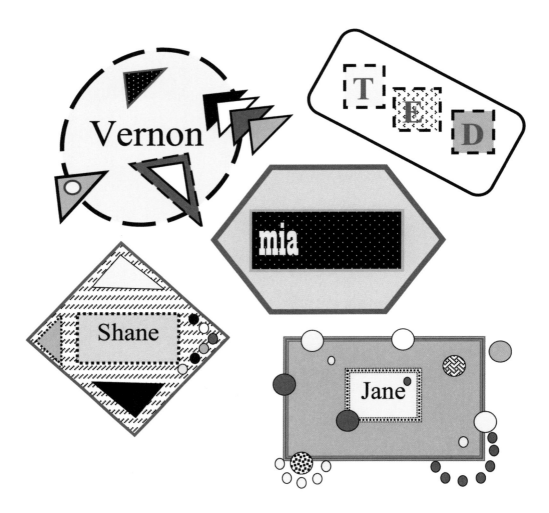

Create new shapes and designs with other names. When you have finished your prayer drawing, you can rearrange the individual shapes on the page to create your final icon.

Now you are ready to re-visit the people on your prayer icon with visual or verbal prayers. Print out your drawing, save it, or send it to others. The more you become familiar with the drawing program that you use, the more prayerful the experience will be.

Chapter 16

For You, the Reader

"Pray as you can, not as you cannot" are the liberating words of nineteenth-century Catholic priest and theologian Dom John Chapman. Drawing with pen and markers is the way I can pray right now. I am grateful for all of the people in my life who taught me various ways to pray and who lined up on the path to cheer me along. They set me free to see the many ways people reach for God.

Praying in Color may or may not be your way to pray. At the very least, I hope it gives you a mustard seed-sized kernel to find a new path of prayer.

notes

1. Thomas Merton, *Seeds of Contemplation* (New York: New Directions Publishing Corporation, 1986), 140.
2. Cynthia Winton-Henry with Phil Porter, *What the Body Wants* (Kelowna, BC, Canada: Northstone Publishing, 2004), 21.
3. Phil Porter with Cynthia Winton-Henry, *Having It All: Body, Mind, Heart, & Spirit Together Again at Last* (Oakland: WING IT! Press, 1997), 84.
4. Parker J. Palmer, *The Courage to Teach* (San Francisco: Jossey-Bass Publishers, 1998), 118.
5. Tony Jones, *Read, Think, Pray, Live* (Colorado Springs: NavPress, 2003), 126.
6. Thomas Merton, *The Hidden Ground of Love* (New York: Farrar, Strauss, Giroux, 1985), 141.

acknowledgments

I owe thanks to many people whose contributions brought this book to print: to friends who read parts of my manuscript and made helpful suggestions, especially Lynn Hunter, Suzanne Henley, Ellen Klyce, Marybeth Highton, and Page Zyromski; to the people who shared examples of their prayer drawings: May Todd (page 60), Margaret Craddock (pages 54, 61), Lisa DiScenza (page 64), Rachel McKendree (page 62), Andrew Mitchell (page 63), Sally Markell, Linda Nelson, and the Women of Discovery and EYC at Calvary Episcopal Church in Memphis; to the staff at Paraclete Press who welcomed this project with enthusiasm: my editor Jon Sweeney, the production team with Bob Edmonson, and the Paraclete Press design team.

I am especially grateful to Phyllis Tickle, who encouraged me to write this book and mothered me through the process, and to my husband, Andy, who lovingly read and re-read the manuscript at all hours of the day and night.

about Paraclete Press

who we are

Paraclete Press is an ecumenical publisher of books and recordings on Christian spirituality. Our publishing represents a full expression of Christian belief and practice—from Catholic to Evangelical, from Protestant to Orthodox.

Paraclete Press is the publishing arm of the Community of Jesus, an ecumenical monastic community in the Benedictine tradition. As such, we are uniquely positioned in the marketplace without connection to a large corporation and with informal relationships to many branches and denominations of faith.

We like it best when people buy our books from booksellers, our partners in successfully reaching as wide an audience as possible.

what we are doing

Books

Paraclete Press publishes books that show the richness and depth of what it means to be Christian. Although Benedictine spirituality is at the heart of all that we do, we publish books that reflect the Christian experience across many cultures, time periods, and houses of worship.

We publish books that nourish the vibrant life of the church and its people—books about spiritual practice, formation, history, ideas, and customs.

We have several different series of books within Paraclete Press, including the bestselling Living Library series of modernized classic texts; A Voice from the Monastery—giving voice to men and women monastics about what it means to live a spiritual life today; award-winning literary faith fiction; and books that explore Judaism and Islam and discover how these faiths inform Christian thought and practice.

Recordings

From Gregorian chant to contemporary American choral works, our music recordings celebrate the richness of sacred choral music through the centuries. Paraclete is proud to distribute the recordings of the internationally acclaimed choir Gloriæ Dei Cantores, who have been praised for their "rapt and fathomless spiritual intensity" by *American Record Guide*, and the Gloriæ Dei Cantores Schola, which specializes in the study and performance of Gregorian chant. Paraclete is also the exclusive North American distributor of the recordings of the Monastic Choir of St. Peter's Abbey in Solesmes, France, long considered to be a leading authority on Gregorian chant performance.

Learn more about us at our Web site:
www.paracletepress.com,
or call us toll-free at 1-800-451-5006.

also in the active prayer series . . .

A new, creative, active way to pray . . .

Making Crosses: A Creative Connection to God
Ellen Morris Prewitt
ISBN: 978-1-55725-628-7 | $16.99, Paperback

The practice of making a cross takes you beyond analytic thinking, and offers a way of prayer where understanding comes from doing. Working with the most complex symbol of Christianity—the cross—we learn to co-create with God in concrete and tangible ways.

Pray with more than your mind. Pray like a psalmist.

Praying with the Body: Bringing the Psalms to Life
Roy DeLeon
ISBN: 978-1-55725-589-1 | $16.99, Paperback

While most books about prayer are meant to be read, this one is an invitation to move in prayer by expressing the Psalms with motion. Benedictine oblate Roy DeLeon guides you with helpful drawings, Scripture texts, and explanations.

Available from most booksellers or through Paraclete Press: www.paracletepress.com; 1-800-451-5006.
Try your local bookstore first.